Portraits of Women

Audrey Hergert

Copyright © 2012 Audrey Hergert

All rights reserved.

ISBN: **1470146436**
ISBN-13: **978-1470146436**

FOR ELAINE

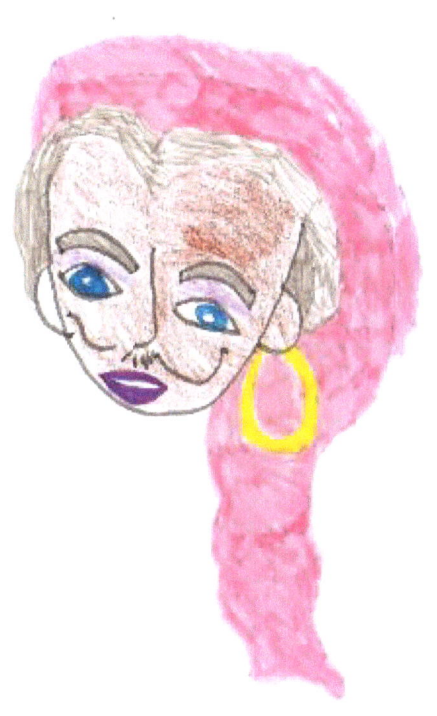

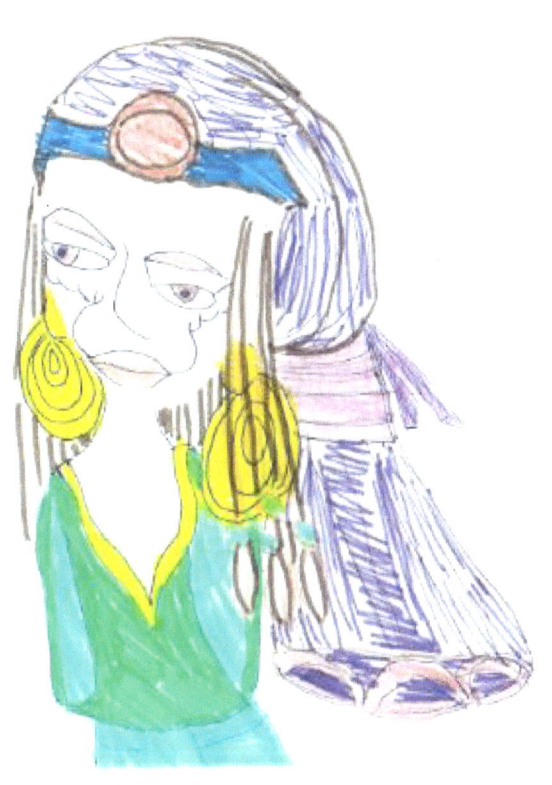

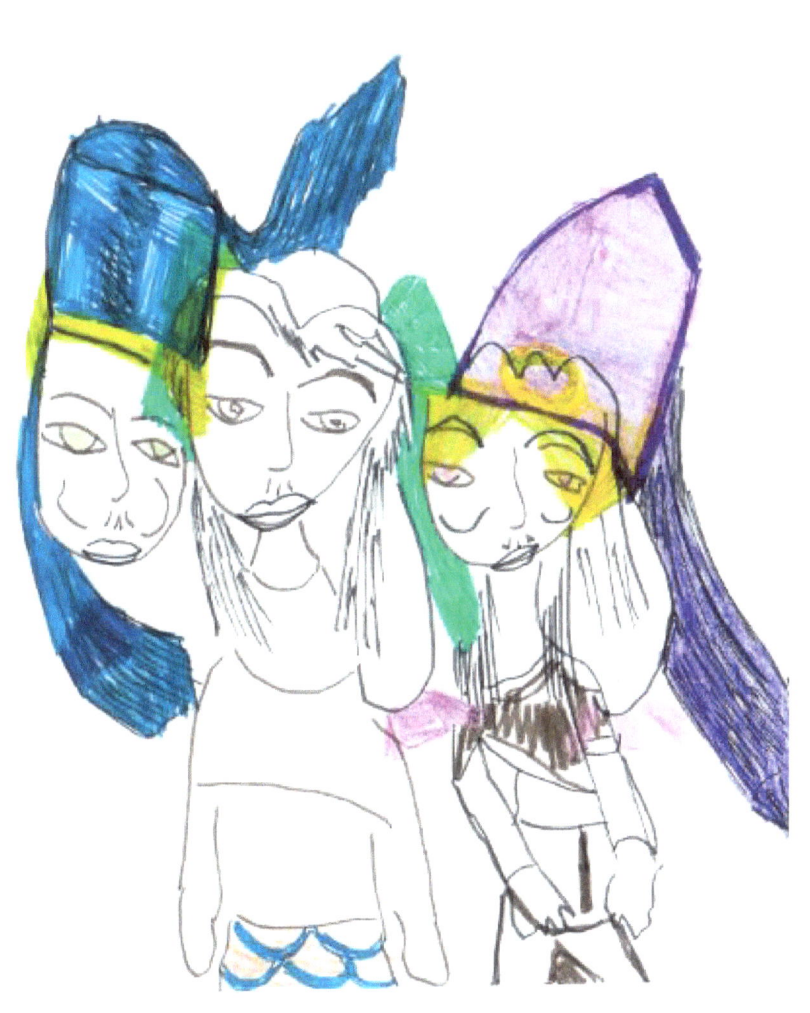

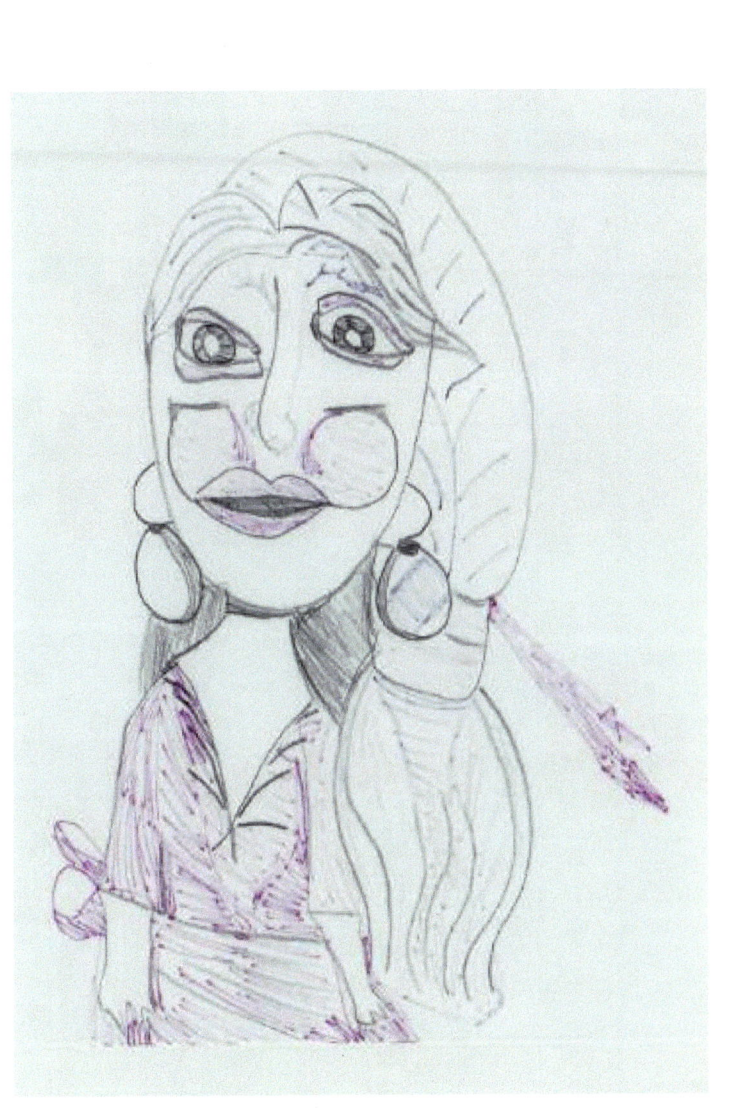

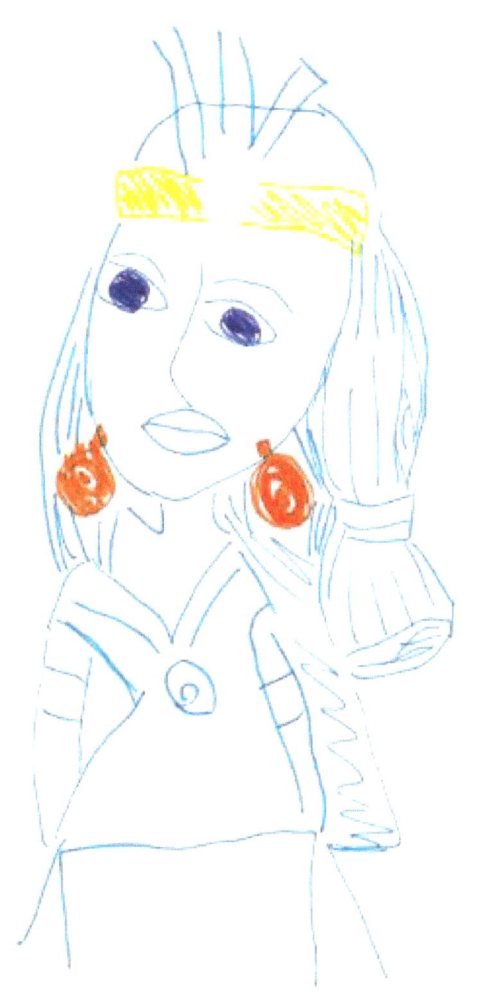

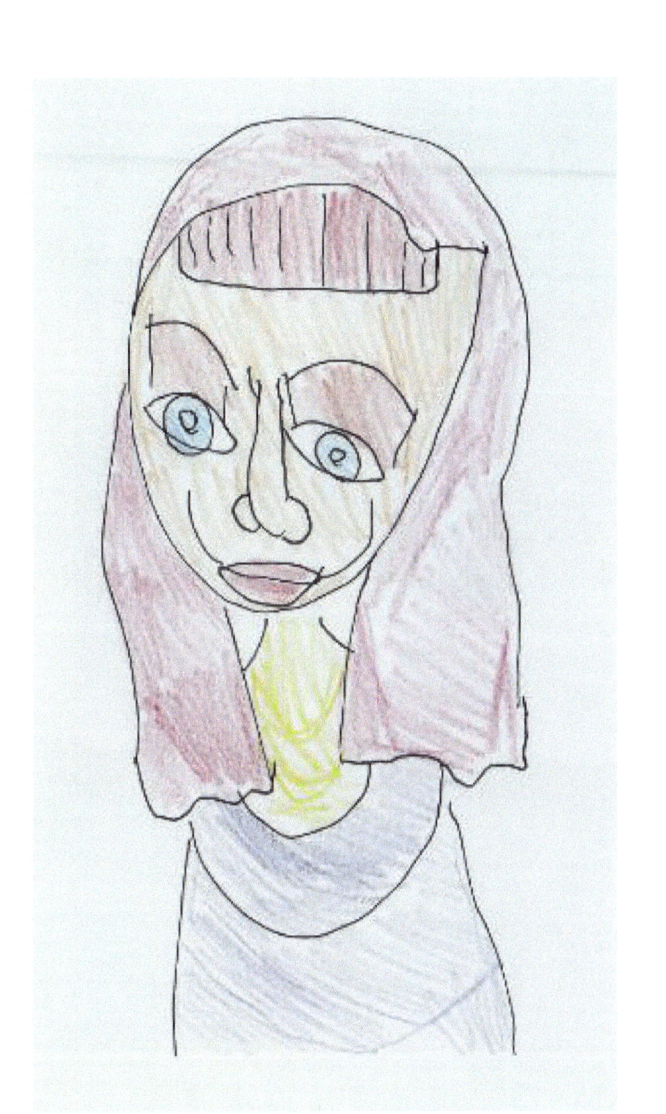

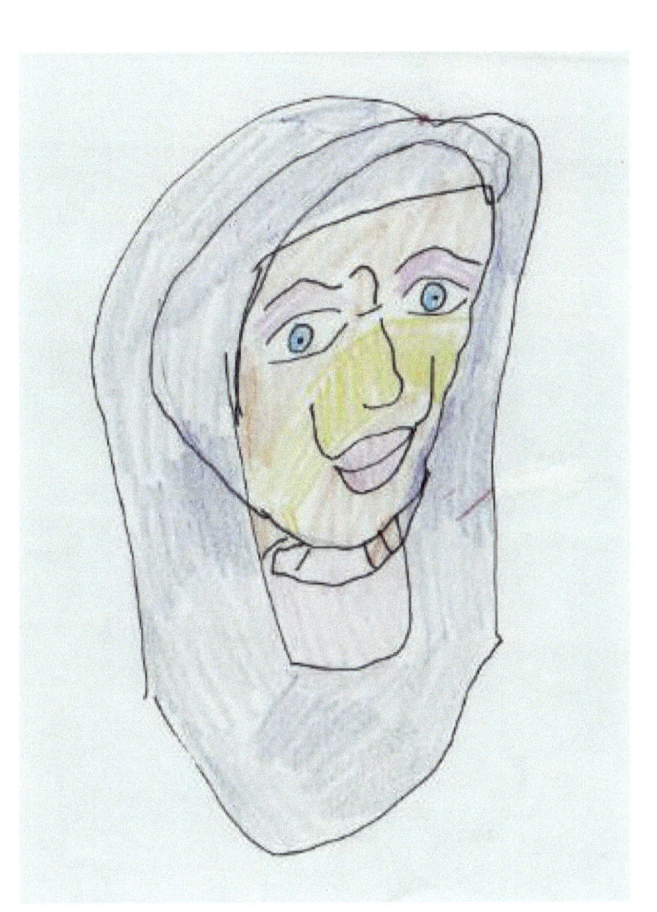

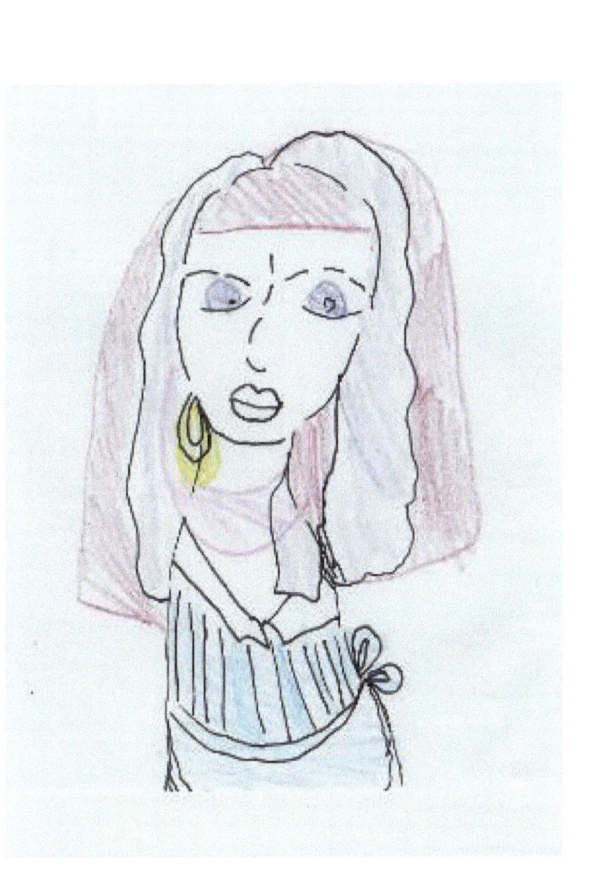

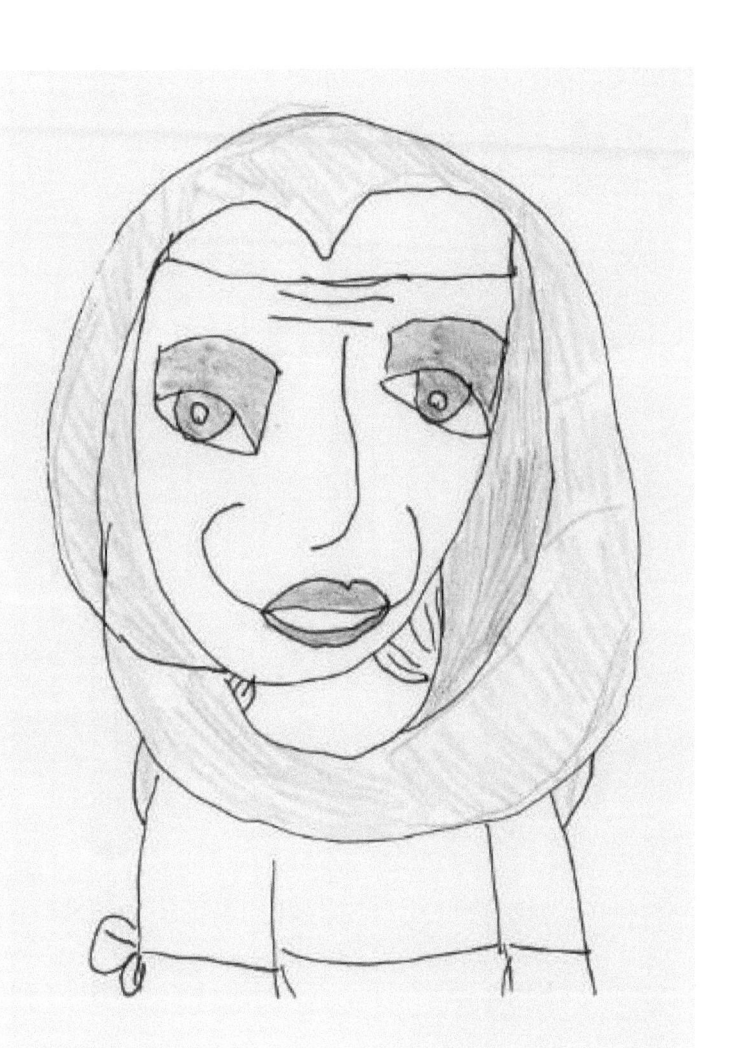

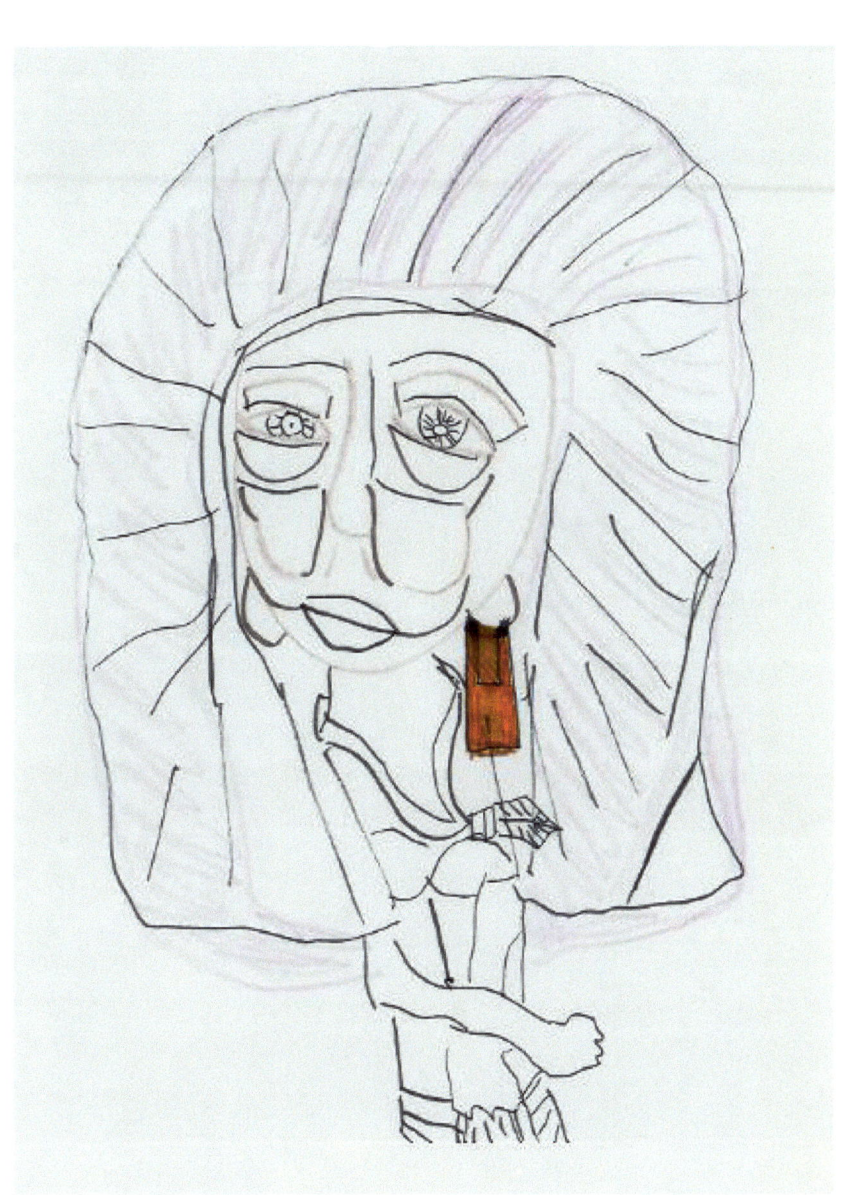

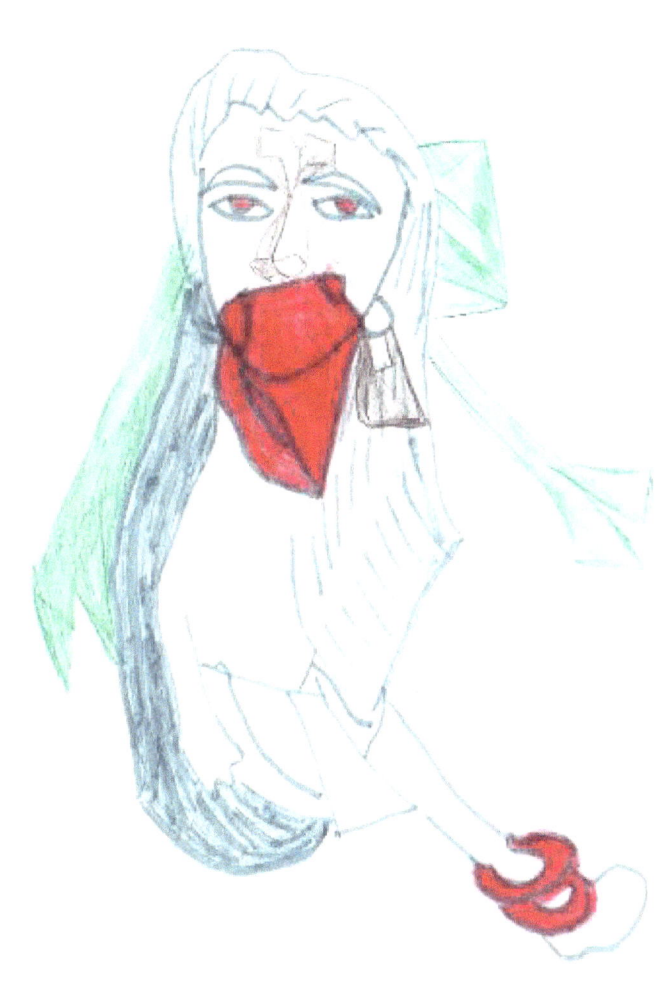

www.ingramcontent.com/pod-product-compliance
Lightning Source LLC
Chambersburg PA
CBHW041211180526
45172CB00006B/1236